RAILROAD SEMANTICS
Number One

by Aaron Dactyl

Photos by Aaron Dactyl
Edited by Adam Gnade & Joe Biel
Designed by Rio Safari & Joe Biel

Published by:

Microcosm Publishing
636 SE 11th Ave.
Portland, OR 97214

www.microcosmpublishing.com

ISBN 978-1-934620-60-1
This is Microcosm #76131

First Published May 1, 2012
First printing of 5,000 copies

Distributed by IPG, Chicago

✎ THE MOTIVATION ✎

*I*was motivated to produce this as a result of Sasha Scatter's *El Otro Lado (The Other Side)*. By chance, a roommate handed me that unstapled mess of folded paper a decade after its release. I was taken aback by the familiarity of his writing, which c o n v e y e d such similar experiences to my own, and the simplicity of the medium was a refreshing break from the artificial, digitized world we're all constantly subjected to, not to mention a complement to the off-the-grid lifestyle train-hopping represents. I realized that our lives—his then and mine now—correlate in many ways, and, with paralleling passion and interest, I thought to continue in the same vein where he left off.

These projects communicate the lives we live—our stories and the stories of others—without the ever-prevalent crutch of the Internet. Every train car is a web page in its own right and every marking a log-in date and blog post of a life lived well beyond what any web posting can convey. This is to those lives lived so intrepid and true.

C o m p i l e d in two weeks, the understanding within these pages took years to obtain. Thank you to everyone who contributed directly or indirectly, to those I met, and those who let me photograph them.

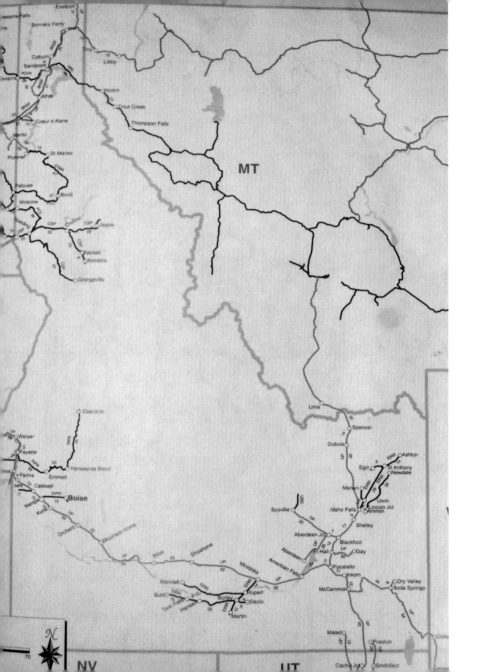

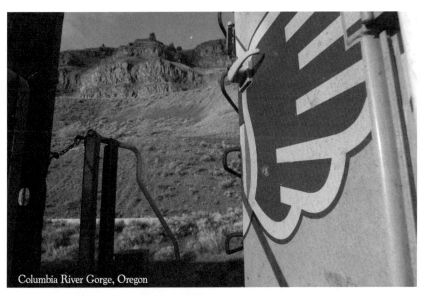

Columbia River Gorge, Oregon

March 19th, Albina Yard, Portland, Or

*M*y knees are aching and swollen; trail mixes and granola bars lie scattered along the mainline track; the pillowcase I wrapped my sleeping bag in and bungeed to the bottom of my pack is torn open; a finger on my left hand is bleeding; my jeans have a new hole in the knee that will only deteriorate further. If I haven't already learned my lesson about this already: Do not try to catch a train on the fly. This one had come from Barnes Yard, a long line of hoppers headed to Wyoming, and I was in a hurry to get out

of town. I thought the train might stop on the mainline as it came through Albina, or at least slow down, but as the uniform train refused to show any sign of slowing, I tried foolishly to catch it. The problem was I was packed too heavy with supplies and upon grabbing the ladder the train jerked me from my feet and began to drag me. I wasn't strong enough to counter my weight against the centrifugal force pulling me down as the train rushed along, though I tried desperately, even dropping a bag of beer that I had been carrying. But as a track-switch approached I had no

choice but to let go, and I hit the ballast hard. If I had I been wearing shorts, my knees would undoubtedly have been torn open like another Marysville mishap. I jumped up quick, and hurt, and watched the train rumble away, feeling humiliated. And now, scattered on a hopper porch, somewhere in Wyoming, there's a bag full of Oregon's finest beer, courtesy of my dumbass.

Regrouping myself, I decided to be patient and wait for a hotshot on the mainline, or perhaps get the DPU of a train departing the yard later that night. A line was being built, and I knew the yard enough to judge by the type of train, the length of the train, and the track that it's on, if it's headed up the Gorge with a DPU or not. Besides, Rabbit just caught out a hotshot from here three weeks ago and made it all the way to Pocatello in the unit, which means he must have passed through Hinkle without breaking up. That's what I aim to do.

Later that night, as the rain came, I boarded the rear unit of a mixed freight train not five minutes after it had been attached. Within the hour it departed the yard. Raindrops accumulated on the cab's windshield and as the train moved through downtown the mist of rain became accentuated by thick fog hovering over the Willamette River, obscuring the city lights. Passing Steel Bridge, the train hit the wye headed east, and I lay down to get some sleep.

I awoke at sunrise, 100 miles from Pendleton, to a river so calm and placid that it resembled a lake rather than the powerful Columbia, whose gorge generates so much power that we harvest the wind and control its water for energy. Orange sunlight cut into the cab from the east, turning the Oregon landscape gold and jostling its molecules alive, and we soon passed the John Day Locks, where the river trickles from a large dam and on the other side the water level rises 50 to 60 feet to border the tracks close enough that I could get out and rinse off my face if we sided. Miles later, at Quinton, we did side, and I put foot down in the Gorge. The stillness of everything—the light, the quiet, calm Doppler drone of the highway behind me—brought me happiness there, alone and away from it all. Sunlight reflected off the towering Oregon cliffs, striking the formations at precise angles of declination with shadows cast in such geometric perfection, that it made me want to major in physics and become a geophysicist. An eastbound doublestack interrupted the calm, rushing by on the mainline as I tried to capture the reflective quality of the river mirroring the scattered cumulus sky and plateaus on the Washington side. These massive cliffs, carved through by ice-age floodwaters, towered over the river in rising sunlight, and whether you're on the Washington or Oregon side, riding UP or BNSF, the view is equally grand.

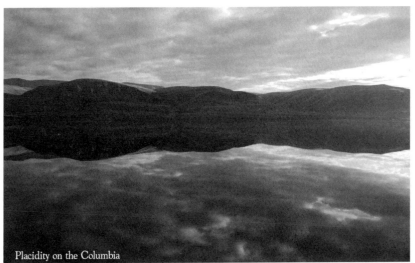
Placidity on the Columbia

Diverging inland from the river after some miles, the train approached UP's Hinkle yard at a cautionary 15 mph. Desert sagebrush, lone cattle grazing dry pastures, wire fences, and a straightaway of telephone lines stretch into the horizon. Shunts of tracks reach out miles from the throat of Hinkle where the train stopped next to a uniform line of Canpotax hoppers that are probably headed north to Walla Walla. I got out briefly and walked between the two lines of trains, then caught back on the DPU as it pulled away. There was no more stopping. The train must have changed crews right there for it blew straight through Hinkle and on toward Pendleton.

A familiar looking valley forms the way to Pendleton that resembles the lower Deschutes River, only dried out and more lush. The land is worked and divided, and sheep scatter across wide green plains that lead to mossy cliffs and hold in the valley. We passed through Pendleton and sided east of there along a lone highway and muddy cattle pasture. I was walking on the tracks several cars up when the DPU's bell suddenly started dinging for no apparent reason. I did not cause it and I did not know how to stop the dinging, and it kept on relentlessly, so I vacated the unit in case someone came back to inspect it. Up ahead a few cars I found an empty well-car with large circles in the beveled bottom. I climbed in, tied my bag down, and rode up into the Blue Mountains with the ground blurring by below me.

It was warm on the ascent— spring-like—leaving the mountains

remarkably less pronounced than last year when I made this same trek and could not set foot down at the pass for two-plus feet of snow. This time, patches of rock form stepping stones along the tracks and dirty snow shows evidence of work being done to the rails—piles of rotting ties, tire tracks.

The descent into La Grande was crisp and scenically dramatic as the train spiraled along the tumbling Grande Ronde River toward monstrous columns of cumulus, all variations of the gray scale, backed up along the eastern rim of the mountains. The train pulled into the yard at La Grande, stopped, and I climbed off to take a look around. Since the bell in the DPU had not stopped dinging, I got away from the train because I knew someone would come to deal with it. Sure enough a jeep pulled up on the opposite side of the train and I watched a car man's feet walk toward the unit and board it. Soon the dinging stopped and the DPU broke off, carrying several cars. Minutes later another general manifest came rolling

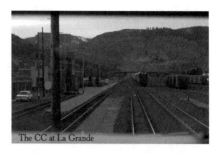
The CC at La Grande

in behind us—mostly reefers—and after calling some cars in, I found them to be headed north of Pocatello, to Blackfoot, Idaho. Since I was thinking about going up into Montana to visit a friend, I decided to take to this train and abandon the one I came in on. I boarded the DPU as it changed crews and we were outbound before long, spiraling up into the hills at sunset, leaving an aggregation of gently rolling pastures below. Looking ahead to the lead of the train winding along the dark and snowy pastoral ledge, I felt like I was aboard the Polar Express heading toward the North Pole. The sun set behind a fiery sky in the west as I kicked back in the conductor's chair for the ride, and though I lost my stash of beer, I had with me a bottle of Maker's Mark whisky a neighbor gave to me for Christmas, dipped in festive red and green wax and signed by the head distiller, Bill Samuels Jr. himself. It is "a collector's item," I was told What better time to enjoy it than now, as we headed into the long night.

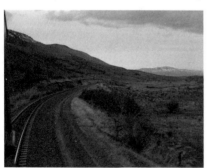

March 21st

I awoke startled by a sudden hissing of pistons as the train stopped, and peering out the cab's backdoor window into the night, I mistook a nearby caution signal for an approaching worker-truck and baled out of the DPU before dawn. I walked the departure tracks in Nampa trying to stay warm until sunrise and after an hour climbed back into the unit, assuming it was not going to be inspected after all. It was light out, and I sat relaxing in the heated engine when a worker-truck drove up and stopped beside the unit. A man stepped out and climbed the steps to the tracks, and I had nowhere to go except into the bathroom to hide. I heard the unit's bell ding as the worker walked about the cab inspecting things, and I kept deadly silent. Seconds later the bathroom door opened.

"You scared the shit out of me!" he exclaimed, jumping back. Young, bearded, and wearing overalls, he didn't look all that scared. I asked if they were sending the unit to Pocatello.

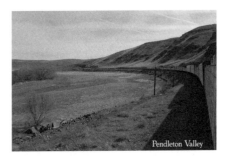
Pendleton Valley

"Next Terminal," he told me, and "I didn't see you."

"Yes Sir."

And we were off.

• • •

Except for those brief excerpts I shared with the UP worker in Nampa, I have not spoken a complete sentence in days. I just write and think while watching the land drift by. Barreling through southern Idaho, climbing up the Snake River Plain on a straightaway of desert prairie, vultures circle overhead and every now and then I spot a cattle carcass strewn alongside the tracks in a different stage of decomposition. Encased by snow-capped mountains to the north and south, the Snake River cuts a path through this landscape, and following it, the train climbs above plateaus left behind. Sad rain sputtered down from a darkened sky, making for dramatic photographs, and on sidings all along the way empty lumber cars gather tumbleweed under their wheel axels like magnets. This could

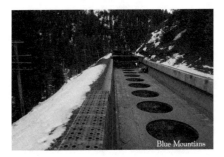
Blue Mountians

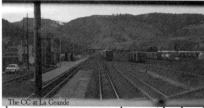
The CC at La Grande

be any western state as long as it's a lot of nowhere.

The train sided east of Shoshone as three lines of mostly white reefers headed west. I had hours to walk around with nothing for miles except train tracks that vanished to a point, and in the distance I could see four-wheelers crossing them. I rinsed my hands in clumps of white slush frozen on the ground and stretched my legs around the train.

Siding again at Minedoka, the bright sun-bleached desert contrasted against the darkened sky, reminded me that photography is merely capturing the way that light hits something. Storm clouds crossed the plains to the south, dark and huge, showering rain on approach, and as black clouds loomed in the northern sky shelling droplets to the Earth. The landscape appeared like a white sand desert, or perhaps an infrared image.

•　　•　　•

I arrived at Pocatello Junction after dusk, ready to flee the DPU. A worker jeep drove up and stopped next to my unit, but thankfully parked opposite

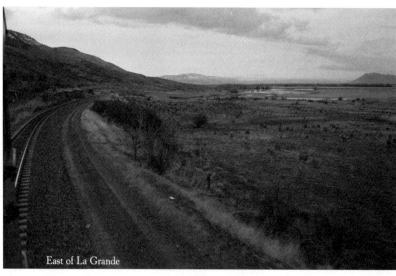
East of La Grande

the catwalk. I baled off the side railing, spraining my ankle in the process and then hobbled to a nearby line of trains to hide in the shadows and catch my breath.

Pocatello is a graveyard of lost trains. They literally litter the landscape, parked wherever there is space in and around the yard, and amidst the manyabandoned yard shops. Boxcars I have never seen or touched before, and from the looks of them, neither has anyone else in the last half-decade. Old graffiti is preserved like a museum here on panels on astounding flat cars still sit bare. How inviting it seemed to make camp for a few days, or a week, in the summer, and just kick back.

It was dark, quiet, and calm, and felt a bit like a cemetery. I moved slowly, careful not to disturb anything , while feeling acutely aware of all those that have come and gone before, for Pocatello has been a major train hub since the early 1950's.

After stashing my bag in an empty boxcar, I walked into town to look for some food. The local grocery store is Ridley's and everyone says it like Ridley is their Grandpa. Oregon food stamps are accepted and I got some hummus, an onion, celery, and a loaf of bread that contained more ingredients than there are words on this page, many of which I could not readily pronounce. They had Modelo though, and two tall boys stuffed

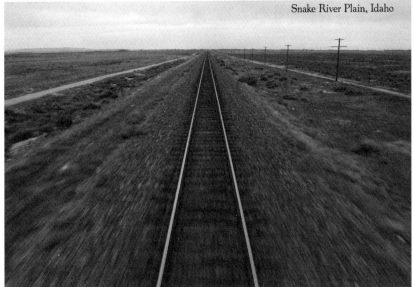

Snake River Plain, Idaho

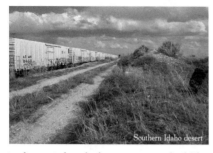
Southern Idaho desert

in the waistband of my pants worked like a charm. I walked back to the graveyard of trains, ate, and took to a neat hopper porch nestled in between lines deep in the yard.

March 22nd

It must be Sunday because just about everything is closed. A gnarly storm rolled in overnight and this morning I could hear thunder cracking over my head, while the darkest cloud I have seen crept in low over the mountains to the south. Minutes later began a heavy sleet. I took shelter under a church awning adjacent the train yard and noticed a visitor's center that looked like an abortion clinic with its reflective doors.

It too was closed, however, a meeting of some sort was happening inside and those in attendance let me in to wash up in the bathroom.

On the other side of town I found a grocery with self-scanners at checkout (bingo!), and some poor kid manning the Starbucks spared me a cup of coffee after multiple moments of intense moral contemplation. It seemed he had never heard the word "tramp" before. I purchased some apples, some pears, a yellow onion, and a six-pack of beer, and rang up everything as a yellow onion and put it on my foodstamp card (the Metolius IPA cost about $2.50 in weight that way).

As I walked back to the yard it began to snow. I took refuge in an empty EEC boxcar near the station, watching the flurries in various forms of flake, sleet, and rain, spit in through the door. Aside from being a graveyard for inactive trains, Pocatello is a busy enough hub. The yard is spread out in sections and fenced off, with access limited mostly to the south side, where Union Pacific has a

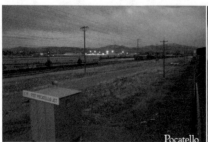
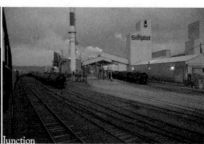
Pocatello Junction
Simplot

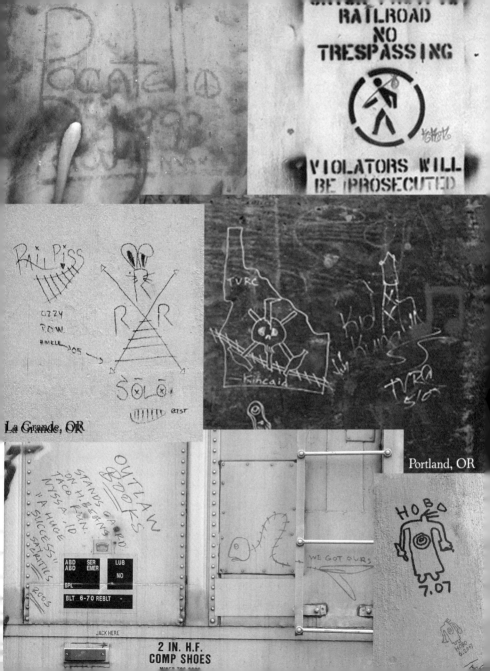

huge office building. There is a refueling pad there so trains on the mainline make a vulnerable catch and can be subject to scrutiny. A lot of trains are headed east this time of year, but not much is headed west, and my aim to make it up to Montana was beginning to look not-so-likely as I became less patient, colder, and did not want to hang around in Arctic weather conditions for days to wait for a train north. I was beginning to feel like I might take the first ride out of Pocatello I could find. Around noon an Iowa-bound general manifest passed An hour later a line of hoppers for local industry left east, and a half hour after that came the first westbound of the day, a line of grainers loaded and destined for Barnes Yard in Portland, complete with a DPU on the push.

· · ·

The sleet and snow ceased around dusk as I made my way down the tracks toward the old hump yard. I could see

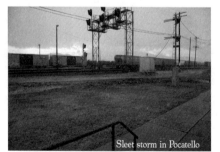

Sleet storm in Pocatello

the Pocatello Tower now, along with the frosty mountains surrounding the bowl, and familiarized the landscape in my mind with pictures I have seen. I hid my bag in the cubby hole on a big-belly hopper and traipsed through the lines for several hours studying the cars, trying to determine where they were headed. I found several cars destined for Blackfoot, a town about 30 or 40 miles north of Pocatello, but nothing built, and I don't even know if the U.P. line extends all the way into Montana any more! The colder it got, the less convinced I became that I wanted to continue further north. It was too cold to even want to get in my sleeping bag and sleep—I wanted to keep moving. The most enticing ride I found was an autorack loaded with SUVs and headed north of Pocatello. *If only I could get in to one of those SUV's and out of this cold,* I thought. I broke the seal on the train's door and tried to open it, but stopped myself before getting to a point where if I opened the doors I could not get them shut again. I did not want to risk locking myself in. I went back to the cubbyhole and thought about hunkering down in my sleeping bags, and just then a line of hoppers pulled up on the mainline headed west, stopping right in front of me with four DPUs inserted in the middle of the line. I eyed with envy, the comfort and warmth they represented, and after a worker walked through, made my way over to retrieve some water and just to

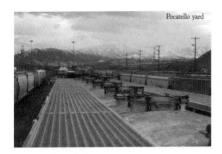
Pocatello yard

POCATELLO
NARX R063 3/660
Pocatello yard

see how the warmth felt.

But in the end it simply felt too nice, and I gave up on the frigid hopper and climbed aboard the westbound train with my stuff. How nice it would be to sleep warmly through the night, wake up back in Nampa, re-up on supplies, and then head back this way again. I sat in the warmth of the conductor's chair looking across the street at the mountains rising steeply to careening white peaks, that earlier in the day had been crowned with

the darkest, most grimacing storm cloud one can imagine, but were now haloed by an apocalyptic sunset of violet, mauve, and yellowish-pink, slowly turning a fiery red so intense that reflections from the puddles on the ground made it look as if the road were on fire.

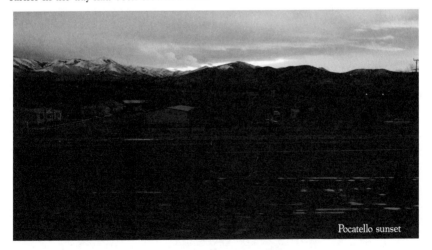

Pocatello sunset

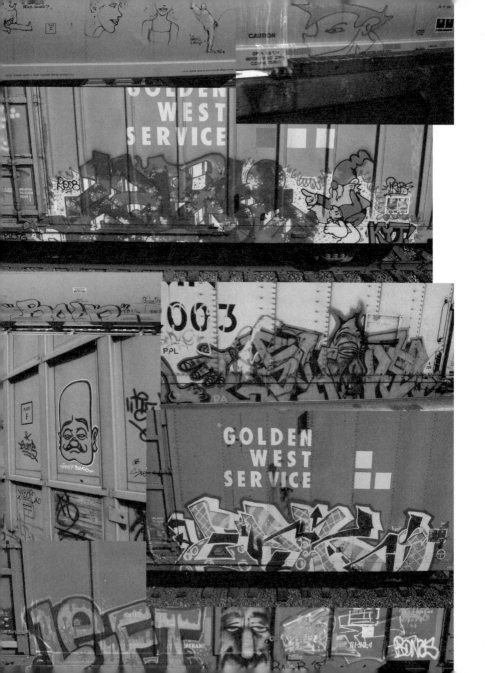

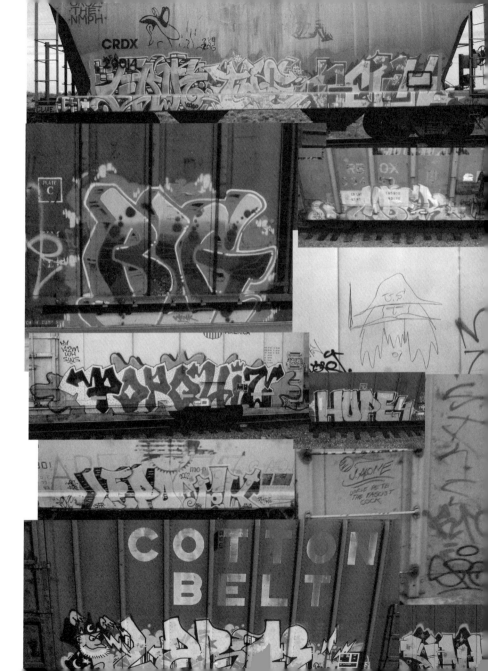

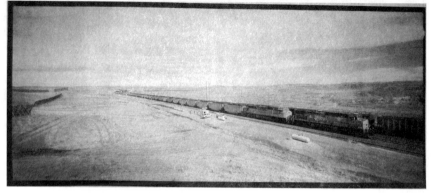

ON THE WAY TO SOMEWHERE ELSE
A lodging company agreed to build a hotel and diner in the middle of, essentially, nowhere
to cater to the needs of railroaders on the coal line who are required to stop and rest here.

In a Town Called Bill, a Boomlet of Sorts

In a Town Called Bill

DAN BARRY

THIS LAND

BILL, Wyo.
For decades this speck of a place called Bill had one. two or five residents, depending on whether you counted pets. But recent developments have increased the population to at least 11, so that now Bill is more a dot than a speck, and could be justified if one day it started to call itself William.

In mid-December those developments appeared like some Christmas mirage: a 112-room hotel and a 24-hour diner. Here. In Bill. Amid the swallowing nothingness of grasslands. where all that moves are the wind. the antelope, the cars speeding to someplace else — and those ever-slithering trains.

Day and night. the trains, each one well more than a mile long. rattling north with dozens of empty cars to the coal mines of the Powder River Basin. then groaning south with thousands of tons of coal. They clink and clank behind the cramped general store and sputtered post office to create the soundtrack of Bill.

But Bill is also a crew-change station for the Union Pacific railroad company. which means that dozens of conductors, engineers and other railroaders on the coal line take their mandatory rest here. Few of them want to be in Bill, but in

Bill they must stay. They are its transients, forever lugging their lanterns, gloves and gear.

For many years the railroaders stayed in what they called, without affection, the Bill Hilton, a tired, 58-room dormitory near the rail yard with thin walls and, lately, not enough beds, as the booming coal business has increased the demand for trains. At 2 in the morning or 2 in the afternoon, bone-tired workers just off their shift would wait for a bed to open up, and then hope for sleep to come.

Union Pacific addressed the situation by working with a hotel company called Lodging Enterprises. The company agreed to build a hotel and diner in, essentially, nowhere, and Union Pacific guaranteed most of the rooms for its weary railroaders.

This is why, one day last August, a woman named Deloris Renteria found herself driving up desolate Highway 59, having just accepted a job as general manager of a yet-to-be-built Oak Tree Inn and Penny's Diner in some place called Bill. But she drove right past Bill, missing it entirely. And when she turned around to face the remoteness, she had one thought:

Oh my God. This is Bill.

The history of Bill is recorded in age-brittled papers and newspaper articles kept behind the bar at the back of Bill's

Bill ★
WYOMING

general store. It seems that a doctor settled here during World War I, and that his wife came up with the town's name after observing that several area men were all called Bill.

There came a small post office, and a small store selling sandwiches to truckers, and a small school for children from surrounding ranches, and little else, except for those trains. At one point the owner of the general store established the Bill Yacht Club: no boats, no water, no costly boating accidents. He sold hats and T-shirts to tourists who felt in on the joke.

At first Ms. Renteria thought the joke was on her. She is 50, the single mother of four adult children; seeking isolation was not her life's goal. But she had a job to do, with a steady stream of clients, almost all of them railroaders passing through, stepping up to the counter at the diner, signing in. signing out.

Now, she says, she likes Bill. When she steps out a back door for a cigarette, she sees nothing but beautiful nothingness.

The hotel in Bill — some call it the Bill Ritz-Carlton — is open to everyone, but is especially designed to accommodate these railroaders. For example, in keeping with a contractual agreement between the railroad company and the unions, it must have a break room, an exercise room and, very importantly, a card table.

Because railroading is hardly a 9-to-5 profession, each room has window shades designed to thwart any peek of

Online: An archive of Dan Barry's columns can be found at nytimes.com /danbarry.

Deloris Renteria manages the
Oak Tree Inn and Penny's
Diner in Bill, Wyo.

checked out of the hotel. He is sipping a Diet Coke at the general store's back bar while waiting for midnight, when he will drive a coal-loaded train the 12 hours back to South Morrill, Neb., where he lives and prefers to sleep.

He says the new hotel is far better than the old dormitory, but adds that some of the hotel's rules are plainly ridiculous. He also expresses shock at the prices in the diner: "Nine dollars for an omelet?"

Actually, an omelet costs $7.99, plus tax, with meat, hash browns, toast and drink. But at least now you can have an omelet here.

At least Greg Mueller, a manager of train operations, can eat a hot roast beef sandwich ($7.49) while thinking about a hill nearby where he can see the crisscross of trains below and the constellation of stars above. At least Marty Castrogiovanni, another manager, can sip a coffee ($1.46) while marveling that Bill, tiny Bill, is part of what may be the busiest train line in the world, in terms of tonnage.

At least now you can look up from your omelet, overpriced or not, and see through the window another train carting part of Wyoming away.

Day and night, those trains, creating a consuming sound undeterred by special curtains and thick walls. It is a sound of money being made, lights turning on and the disturbed earth rumbling at your feet. It is the sound of a dot called Bill, too busy to sleep.

daylight and thick walls to snuff out sounds like vacuuming. The hotel also has a "guest finder" system that uses heat sensors to signal if someone is in a room, possibly resting, almost certainly uninterested in a cheery call of "Housekeeping!"

The Ritz of Bill still has its growing pains, its clash between two cultures — hotels and railroads — as evidenced by a slightly misspelled sign on the diner's door: "Union Pacific Guest: Please remove kleats before entering building. Automatic $50 fine for violation!!!!!! Thank you for your cooperation."

Providing mild counterpoint is Jarod Lessert, 35, a train engineer and one of Bill's longtime transients, who has just

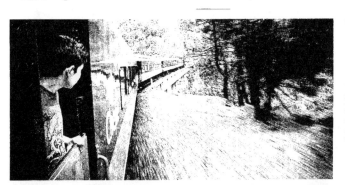

📷 Riding the Rails
Through a Canyon

Images of the Chepe railroad that travels through the dizzying heights and rugged depths of one of the world's largest canyon systems. More than 400 miles of train tracks traverse the craggy landscape in northwestern Mexico.
nytimes.com/travel

MAR 17, 2008

Hey Joe, I got the letter about Bill, I told you it was out in the middle of nowhere, I figured it might have been built up by now after 20-25 years. But I guess not, So, maybe if the bus goes through Bill, or unless I can get a ride in and out of there to check it out, I don't think I'll ever go there, there's supposed to be a yard there though. The picture is the North end, I can see the "Black Thunder" Coal mine Jct, that cuts off to the right in the picture, and the track running Northward, So, I have to stay with what I know, I have to stay with Edgy, Joe, And the other spot where I go to covers enough as it is, I would like to nail some up. Coal as though, but I don't think there's any cover to speak of in Bill, except for the cover of Darkness, And that me either, in Edgy, I can do it because its all right in front of me, And I'm out of the weather and up-off the ground, just between the two spots I do go to is enough to keep me busy day and night, Joe, and I can still cover the entire TiE from there,

Well, I'm halfway thru this, may 21, maybe Sooner, I get more worktime off between now and may 21, it will all work out in the long run, I'm getting too old to be going thru this any more, I'm feeling old in here Joe, 50 years old now, its sneaking up on me,

I guess my buddy Rerros doesn't write to me any more either, Do you know him, Joe? I'm going to have to ride the chain back to Eugene For a stupid ticket when I'm done here, As soon as I do get out I'm getting ready for the Edgy run, Load up on markers and go for the long bomb run and see if I can get a touchdown, I want at-least 50 markers this time just to start

I started rewriting one of my old manuscripts called "Diesel Run", I had Diesel Run one, two, and Three written at one time. I don't remember who I sent it to or what, can you send me Trackside inc's address at Faded Glory? Anyhow, Dunore 900 pages total, I don't expect to get 900 pages written in the next 2 months or so, but at 5 pages a day I could get about 400 pages done, I want to get a laptop and type it all up on a Flash disk or something, then send it out to a publisher, But I'm writing to pass the day, Time is going a little faster too since I started writing. Plus I'm working out, not smoking, And I don't know for sure, but I'm going to try to quit for good, I need the extra energy for my runs, I'm getting too old to keep trying to Fight the Down pull of smoking all the time, it runs you down,

There's really not anything to talk about because you've never answered back any of my questions or anything in any of the letters I've written Joe.

```
                DISBURSEMENT RECEIPT

     Stamp:  03/12/2008 10:23
      Type:  MEDICAL CHARGE
    TranID:  ██████@
 Component:  NORCOR OR JAIL
      Name:  EASLEY, JOHN ██████
    Number:  ██████
CELL BLOCK:  CELLBLK███
     Media:  INTERNAL
    Amount:  $      1.00
       Fee:  $      0.00
   Balance:  $      0.00
     Owed:   $    897.80
      Note:  Antacid 3-8-08

X _____
Authorized

X _____

Inmate Address Info:
```

2.

Alls I got in the last letter was the Article on Bill, No letter, I'm getting mail with No Return address on it and I have No idea who or where or why. Because they're not giving it to me!

Today is Saint Paddy's Day, and I'm Losing the Traveling Fever again. Just Don't Feel Like Doing all that Traveling Around Any more. Joe, if I can make enough money when I get out, I'll Just Ride greydog to Denver and Start from there on my way from Japan, Its Like What? A 24 hour Bus Ride to Denver from Portland? Look it up on the computer for me. will ya? And How much it costs. I Need to get going.

Cover Some Ground on This Run as fast as I can Grey Doggle to Denver for me Joe, then Ride the Train across. Need okay to Eddy and be there Lickity-split so I can make up for Lost time. Coming Back I'll Ride the train All the way though. And Theres Another Run we need to make Joe, and that is in the Seattle Area, but I won't give exact Location though. Grain Cars Joe, the Brown ones by the Hundreds. Theres No Job on them, I've gotten a few up on em, but I Never have a Location to work on them, I got one In Seattle though that I found, Nail A thousand of um or So. Think I'm Joking Joe? I Told you I go for the unit trains. Nothing Local, I'll go for some Boxes or whatever you off and on. I used up a whole Box Joe of those Blu002 But it was all on Canadian Cars and Cross Country Cars, Nothing Local. Did you give Some one my Address Joe? I got a letter with No Return Name or No- or it, And they won't give it to me, So, I have to wait till I get out to See who wrote me, Because its In my Property Now. Well, Talk to you back to work yet? Give a Yell!

Send me Some Stuff Joe, make Sure you have a Return Address on the letter.

John
Onward!

MY Hotel Bill here, to date.

21

Elizabeth ?

← WHISTLES → SPOTTED FROM OLE SPEEDY
COLORADO TO OREGON
DENVER → PORTLAND

1. "THINGS DRAG ON" — 1/09 — MID CAR — FRASIER CO. — MOPAC GON.
2. NO CAPTION — 1/09 — LADDER — FRASIER CO. — U.P. HOPPER
3. No CAPTION — 10/08 — MID TRAIN — WINNEMUCA NV. — CTGX HOPPER
4. NO CAPTION — 7/08 — END CAR — SPARKS NV. — HATX ROCK HOP 100057
5. NO CAPTION — 7/08 — 2nd 2 last — SPARKS NV. — HLMX ROCK HOP?
6. No CAPTION — 1/09 — BLACKBOX — SPARKS NV. — TTX BOX
7. "SELF DIMINISHED" — 2/09 — BLACKBOX — SAC CA. — TTX BOX
8. "CAPTURE ?" — 1/09 — MID CAR — SAC CA. — TTX BOX
9. No CAPTION — 1/09 — BLACK BOX — SAC CA. — RIOGRANDE OPEN HOP
10. "SO BUILD SO TENDER?" — 5/06 — LEFT OF DOOR — SAC CA. — ? BOX
11. "WHISTLE DESTROYER" — ? — END OF CAR — SOUTHBOUND — U.P. GONDOLA
12. NO CAPTION — 12/08 — LADDER — DUNSMUIR — TTZX LUMBER
13. NO CAPTION — 12/08 — LADDER — DUNSMUIR — AOK LUMBER

FAVORITE →

(14) "BROKEN EGGS ?" 7/08 PROPANETANK DUNSMUIR BLUE PAINT

(15) "ON WOUNDED KNEES" 7/08 ROUNDHOUSE DUNSMUIR BRIGHT WHITE :-)

(16) "N B D" 7/08 RIGHT NEXT TO STATION DUNSMUIR

Hi Pamela →

(17) NO CAPTION 7/08 END OF CAR DUNSMUIR S.P. BEER TANKER

(18) NO CAPTION 2/07 MIDCAR MT. SHASTA HERZOG (2) ON CAR

(19) NO CAPTION 1/09 BLACK BOX K FALLS : COTTON BELT (2) ON CAR

(20) "SOUTH POX-EUG" 7/09 MID CAR K FALLS U.P GONDOLA BLUE PAINT

(21) "LUCEY" 9/07 MID CAR K FALLS GNTX Hopper Yellow Paint

(22) NO CAPTION 5/08 END OF CAR K FALLS U.P. GONDOLA

(23) "February Wary" 2/09 Black Box NORTH OF CHEMULT PUORE Grondola WEST SERVICE

(24) Eugene → 1/09 12/08 11/01 12/08 2/09 1/09; WHISTLE AOK ARMN ARMN BIEVER LUMBER

(25) NO CAPTION 12/68 ENDOFCAR JUNC. CITY CNW GONDOLA

POCATELLO TO PORTLAND
(Nampa, Huntington, La Grande, and Portland subdivisions)

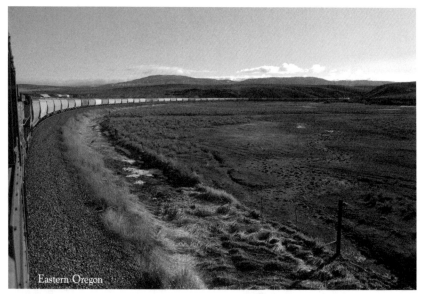

Eastern Oregon

March 23rd

The train made good time to Nampa—too good of time it seems. I was awakened in the dark by men hollering and flashlights flashing, to the feeling you get when you've been busted shoplifting after having a bad feeling about it in the first place. I didn't know what was going on, how many people were doing the hollering, or who they were. They didn't know how many people were on the train. Turns out it was one worker routinely inspecting units, and just I.

The horror stories this guy must've heard! I mean, only such harrowing experiences could lead him to be so frightened of a train rider. "Weapons!" he yelled. Did I have any? "Alcohol!" He spotted my bottle of water and panicked that it may be vodka. My Union Pacific hat sat on the dashboard and my Union Pacific shirt made him think I marauded one of his fellow employees to obtain them.

He made me stand up in the corner of the unit, and with his flashlight on me, inched forward to grab the inspection card, then jumped back like I was going to bite. I'm sure I looked menacing in my long johns, socks, and big oval glasses! But after he flicked on the dome light in the cab and could see me, we began to talk.

"I was freezing my ass off in Pocatello," I told him truthfully, so I climbed in the unit to stay warm. "I'm headed to Portland for work" (a half-truth).

"You guys," he referred to me, "always scare the shit out of us." And it was happening more and more that they, the workers, were encountering us, the tramps.

I assured him I was traveling alone and no one else was in any of the other units—I did check. I iterated that I would not touch anything and that I'd get off the train if he asked me to.

It was four in the morning and freezing cold in Nampa and I was no longer interested in getting off the train, at least not right then. The worker left then came back minutes later to tell me he was going to duteously inform the outbound crew they had a rider, and that they probably would not care, but that he was not going to call the Special Agent, because that's not what he's about.

"Look, I don't want to get in trouble and I don't want to get you in trouble, so if anyone asks, I'll say I got on in Nampa."

And with that we had an agreement.

"Alright, I didn't see you," he said, and told me there was not a lot of traffic on the lines so I'd make it to La Grande in about four hours, but that the unit was going to detach in Hinkle, so to beware. He stepped out the cab's back door, but then stepped back in to say: "And if you have to go to the bathroom, go outside or use the toilet."

I expressed my disbelief that he felt the need to tell me that, but he was serious.

"We have to clean these things out and you wouldn't believe the kinds of things we have to deal with," he told me.

That must be where the horror stories come from.

March 24th

I awoke at sunrise around Baker City, the high desert of Eastern Oregon; a place I'd been through twice before, but never so in the day. Shadows cast gently from the mountainsides as light fell perfectly across the frosty desert-prairie, of ice and mud, bales and bales of hay, and wire cattle fence encasing perplexed bovine that were probably

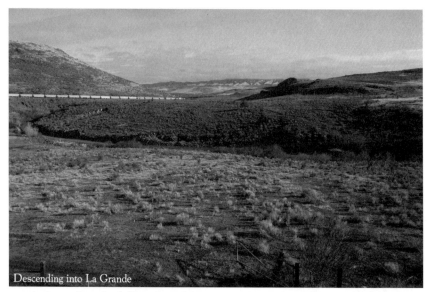

Descending into La Grande

wondering, *what the hell is that damn thing?* Soon familiarity returned as the train went spiraling back down from the hills like the Polar Express in reverse, wrapping around the land down into the Grande Ronde Valley, stopping at Crooks siding, about ten miles from La Grande. The worker was right, there

Crooks siding

wasn't much traffic out on the lines, but hours after arriving at Crooks, the train remained, with mountains on either side and a highway keeping me in check and indoors. I was too frigid to wander anyways.

Last night I had dreamt of trains as I sleep on them, of workers, engineers, and car men, and I woke wide-eyed remembering my encounter earlier in Nampa. I now felt excited about wandering around La Grande on my own, visiting the library, to corresponding from the road, and washing up in the bathroom. I looked forward to a hot cup of coffee—if I can manage it—and a good reading of the

newspaper, because after a few days on the train, I felt out of touch with society and the happenings in the news. But alas, my train remained at Crooks, idle, all morning. Occasionally the engines revved and hissed, building up so much momentum to move, only to settle down again. Another train passed, an eastbound, then another, then a third. Still no movement on my end. I thought about hitchhiking to town, but I had a feeling that as soon as I left the train, it would take off without me, so I bided my time, thinking, writing, and observing the land, which had entirely transformed under the shifting sunlight.

Six hours of idleness later I started to feel like the train had been abandoned. I thought back, and except for an overnight junk train on the Brooklyn sub from Portland to Eugene, this is the longest I've ever been sided at one time. I began thinking that "I didn't see you" in Nampa didn't stand after all, and the crew knew I was back here

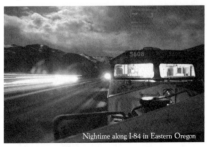

Nightime along I-84 in Eastern Oregon

so they chose to side the train outside of town just to fuck with me. That did not seem farfetched at the time. Then by the seventh hour, when twelve hours was up and the train still had not moved, I realized there probably was no crew on the front anymore and that it may be hours still before a new crew arrived to take over.

Only one westbound had passed all day—a line of empty well-cars—and it was getting too dark to hitchhike, not to mention too cold to sleep outdoors in La Grande. As the sun sunk lower in the sky, I altered my mindset, resigning myself to waiting another day on the train. I ate my hummus, celery, cheese, and raw onion, drank my last beer, and lay on the unit's floor with my eyes closed.

An eastbound line of empty coal cars rushed by, and a half hour later came a westbound local, a short general manifest with a pusher unit with the cab door wide open in the back. The sun set over the mountains as a third westbound train passed and I lay back down on my sleeping mat with my eyes shut as the unit-I-was-in's horn began sounding over and over. The train charged up, exciting me, and then died back down. I drifted in and out of light sleep until, seventeen hours after leaving Nampa—twelve long hours idle

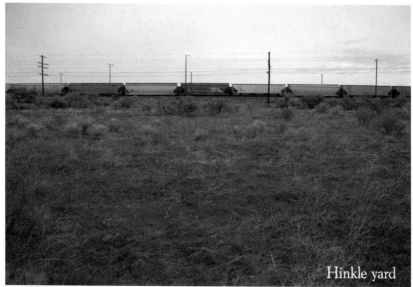

Hinkle yard

on a siding ten miles from La Grande—the train jerked into motion. Ten miles later it became obvious that the crew change had taken place back at Crooks. La Grande came and went. I continue to lie on the unit's floor as we began our ascent back up into the Blue Mountains, but remained alert, aware that I did not want to be in the unit when it arrived at Hinkle. I awoke hours later atop of the pass, where a fresh snow covered the ground, and again in Pendleton. The train sided in the Valley just before Hinkle and there I stumbled forward on the tracks in the dark, sputtering rain to find a back porch to ride the rest of the way.

March 24th

I slept through the rest of the night despite the cold, spitting rain, and arrived in Hinkle early in the morning while still dark. The train's mid-line DPUs had already been cut and the line reconnected, while the rear DPU remained. But not knowing if it had

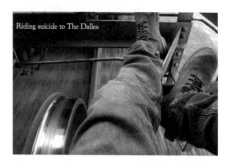

Riding suicide to The Dalles

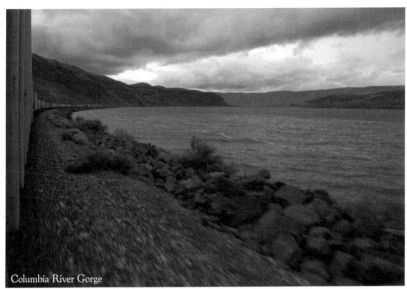
Columbia River Gorge

been inspected yet or not, I stayed off of it. There was little activity in the yard and I wandered around the adjacent desert, still green from all the rain and snow, I surveyed the remnants of old hobo camps huddled behind the low shrubs, inspecting the trash, empty cans, railroad-issued water bottles and beer bottles with their labels worn off,

Sandy, OR

followed the tire tracks, jeep paths, and crevices cut into the moss, grass, and sand down to a small stream and back, never straying far from my train in case it were to suddenly take off.

Hours had passed into the afternoon when I left my bag on the hopper porch and walked back to the rear unit to see if had yet been inspected. Suddenly, the train jolted forward without ever releasing any air, and I was caught between the porch where my bag was and the rear unit, about a distance of 30 cars. I had to stay with my bag, and I ran back toward the porch and ran. But the train accelerated steadily, outpacking me.

Before I even made it back to where my bag was, I had to catch on a different grainer altogether so that I didn't lose the train entirely, and I ended up riding a suicide-porch through the gloomy, rain-sputtering gorge, barreling along the edge of the Columbia River all the way to The Dalles. For the most part I remained seated, but occasionally I couldn't help crossing porches side to side to capture a better picture. When the train finally stopped in The Dalles, I walked up and retrieved my back, then hiked back to the rear unit and climbed on to see that the inspection card still hadn't been checked. The train sat idle in the yard as the sun set on The Dalles. An hour later we were off.

March 25th

Stalled again at sunrise, atop a bridge with no river in sight, I spent the morning trying to figure out if I was in Hemlock or Hemlaw, because the tracing system's automated voice could not correctly pronounce wherever it was. I figured I must be close to Portland since it had been raining non-stop, and I listened to the radio frequency in the unit. I could hear Engineers contact Albina Tower, and Albina contact Lake Yard for arrival. Men spoke of pulling up to a "car man's crossing" and

"putting on a yard crew to take it the rest of the way."

"Here we go," an engineer said.

Minutes later a WBD GM passed.

An hour later, fearing another abandonment, or another long day of waiting in one place, I climbed off the train and walked across a muddy field to where a red barn stood. There was a bus stop across the street and I waited under a produce stand awning across from it. Turns out I was in Sandy, and soon the bus arrived.

"I just got off that train," I said dripping wet to the bus driver, a big middle-aged blonde women who was obviously bored with her life's routine. "I don't have the fare. Can I have a ride?" I asked.

"I guess," she said to this wet bum.

I tried to give her $0.30 I had scrounged from my wallet, but she shooed me to hold onto it. The next stop we came to picked up a pair of riders, one being an eccentric middle-aged woman who wore way too much make up to be believed. Ironically, she asked me for $0.30. It was all that I had, but I gave it to her figuring she was short of fare herself.

"What do you need it for?" I asked.

"Dope," she responded.

"Well, you're not going to get a lot with $0.30," I told her.

She asked me if I lived in Sandy and I told her I had just come in off the freight train from Idaho, to which a spattering of disbelief erupted from her mouth as she admonished me, warning me of the dangers like a bad parent. I could only listen for so long and eventually she became distracted by her own temporary tragedy and had to call her pharmacist. I laughed to myself as she argued with and insulted the pharmacist for taking too long to refill her prescription. Nearby, an older, ugly woman, said to a man, "I wished she lived in southern California, away from the rain and cold."

When I got up to exit the bus at the MAX stop on 92nd, the woman reached out and handed me a roll of dollar bills. Apparently she had been listening to me talk too.

"Good luck," she told me.

Faith in humanity restored.

know I just got off that train! Snake River, Idaho, Westbound in Eastern Oregon, Pendelton, OR, Hinkle Yd. VAMPA → PORTLAND, and Portland OR. There were some others I did but can't at the moment recall... At Hinkle Yard they had me running around the desert, bailing out of engine ~~~~~ Dodging workers, and became only my line of

(5) jumping frantically off sudden and hiding behind sagebrush and Tumbleweed waiting for the sun to set, getting taken to the hump and running back across the yd, and a rare white owl nearly attacked (6) me! I feel about 10x better about that yard now. I believe I can navigate it in the future In the end it quieted (when it got dark)

31

E Peo ILL. 85°

DIAMOND
HORSE SHOE
CAFE

LOUISVILLE
VE THE RIM

Roseville
Bud
88
B 222

SAG
8/6/90 ESSEX, MT.

EXCESS HEIGHT
LARAMIE
'156

The
La
7/96

TWINN Stack
LINDA

1-06
GROV B.

SHORT STORIES
MT. PLEASANT, TX
98
CAUTI

Speedy
g

entro Sant

HELLOUVA FROST
LAST NIGHT
fellas.

ST. LOUIS. MO

THE
KENTUCKIAN
5-02

oid
WY

CHICAGO
2002

PLATE
K
9/02
Chicago

R minor LARRY 5-11-05
Burt + N.B.F
K Butte CA.

"Shoestring"
8-99
'team'

tin
m
a
n
Albany, OR.

My little
Kitty's
car The
Rail
Bandits
AB, KS, DS, JB, CM, MS
7/6/05

VIRGINIA
DIXIE IRON FIST
CR
35

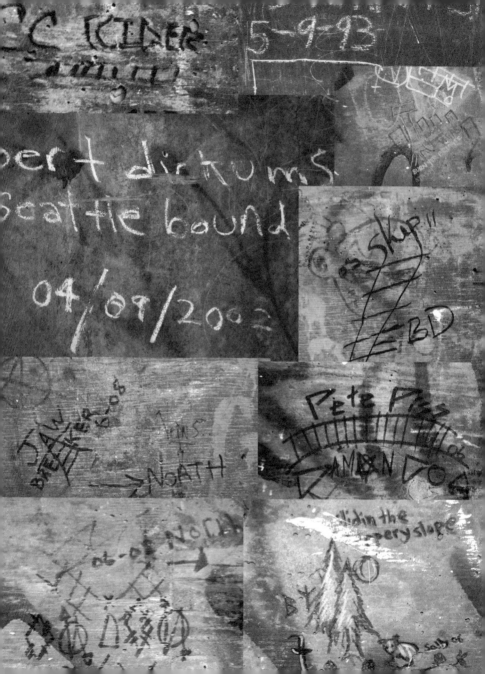

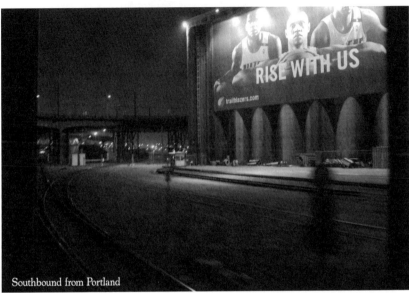

Southbound from Portland

The ride down to Eugene took over fourteen hours. I caught out of Albina Yard on the southbound I planned to, around 7:30 p.m., climbing into an IBT boxcar about halfway down a line of empty lumber cars. As the train crept around the grain mill along the river, three winos emerged from the shadow of a parked hopper and approached the train—two men and a woman, looking unsuited to travel. They wore jeans and windbreakers, hats and mustaches, carrying only little backpacks. I presumed

they were going south. And I knew that aside from two empty IBT boxcars in the middle of the line, one of which I was in, the only other rideable on the entire line was an empty SRY boxcar on the very end of the train—everything else was lumber.

"Going to Eugene!" I hollered, waving from the boxcar door and pointing to the empty boxcar directly behind mine.

All three hesitated, seemingly startled by me, as if they did not know

what to do next, and as the train crept on I looked back at them timidly approaching the empty bulkheads as if they were going to climb on one and ride, and they disappeared out of sight. The train rounded the curve and cut through town, picking up speed. Red lights and headlights flashed by spotlighting the inside of the boxcar with the Doppler dinging of the crossing gates and the unit's horn blaring up ahead. Switching tracks at Brooklyn, the train slowed and pulled into the yard, where, up ahead, I spotted a jeep drive up and stop beside the train. The jeep's door opened and I could discern from a distance that the person exiting the driver's side was not wearing any reflective safety vest; I saw only the flashing gleam of an object on their upper-torso, about where a badge would be worn. I jumped back into the shadows to make sure my bag was well packed and held my breath as my boxcar rolled slowly past the jeep and continuedon just enough that the last train car stopped right next to the parked jeep. With a wind of relief, I watched through binoculars as the dark clad figured walked up to the train and led away three slender silhouettes. Someone must have spotted the winos and called them in. *Were they, in turn, now going to tell on me?* I leapt down from the boxcar and hightailed it into some nearby bushes just in case. But all it took was thirty seconds until the train aired up and began to move again. I hustled back to the train and climbed back on headed south, bound for Eugene!

The night was crisp and cold as the train sailed smoothly above Oregon City, and I was once again reminded that I am happiest in life when on a moving train. The train hooked along the river's path and pulled into the hole at Coalca

Willamette Valley

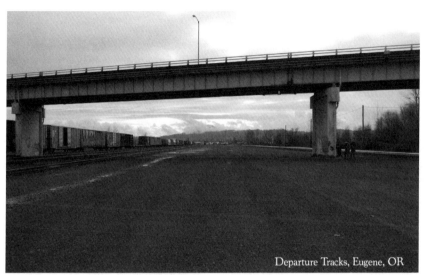

Departure Tracks, Eugene, OR

alongside an embankment of mossy boulders buttressing Hwy 99 and the dense wooded riverbank. I sat there for hours on huge rocks looking overtop the train, up at the stars. The train stopped again on the mainline in Woodburn, right across from the cemetery, as it often does, and I walked around briefly to relieve myself, then lay in the boxcar down to sleep.

I must have spent the night on a siding just south of Albany, but I did not care to know exactly where. I awoke at dawn as the train jerked into motion, the lush, wet valley landscape outside eternally familiar. Soon the train rolled through Harrisburg and on toward my favorite leg of the trip, paralleling the wooden-trestled P&W tracks along farmland plowed and planted seasonally, across bridges spanning flooded rivers, through Junction City, with its proud water tower bearing the town's name for all to see, then along a wet two-lane highway for the slow crawl into Eugene.

I had been in touch with my friend Rabbit, who had already made it to Eugene from Albany and upon my arrival he, Bindle Bob, and T-Box were waiting for me behind a pillar under Maxwell Bridge. It was quite the early morning reunion. But Rabbit was headed south to Roseville, and beyond, while Bindle Bob was due back north in Albany, and eventually they each found boxcars on already-made lines going their appropriate directions. We spent all afternoon on the departure tracks of

the Eugene yard, sitting amongst lines of trains shooting the shit.

After the Northbound to Albany took off, the southbound remained, and after dark it sat on the mainline across from the yard. T-Box and I walked along the tracks to keep up with Rabbit and found him still in his chosen boxcar, waiting. I opened a beer for us to share and handed it up to him, a near ten-dollar Belgian brew I "acquired." Just then the train aired up to go and he finished off the beer whilst rolling away. A few seconds later his drunken laugh called back to me. I turned and I saw T-Box jump out of the way and the bottle shattered on the tracks just missing our bodies—a hobo's *thank you* and *goodbye*.

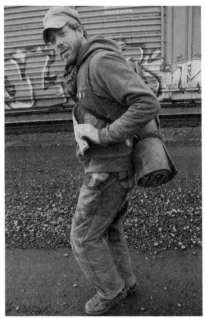

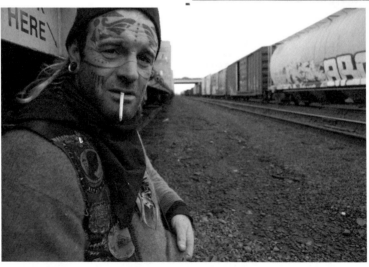

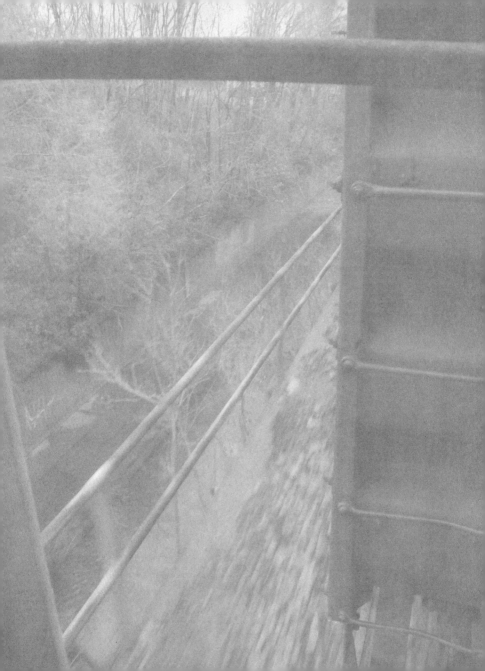

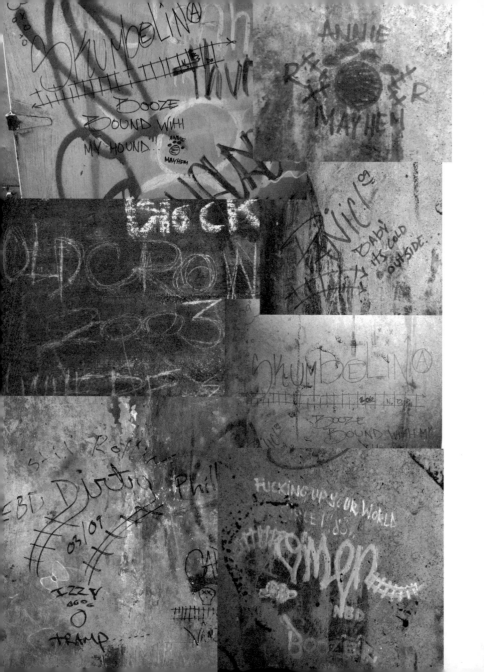

Dick
I L 60-9
11-5-01
C FT 7400
Portland, OR

STEREO
EUGENE
D4 COAST CORP.
SEE YA THERE
ZNOX

Whiskey
Dick
2-23-05
Eugene, OR

H 16-2 W 10-7

Whiskey
Dick
01-12-05
Eugene, OR

WATER BED LOUS IN LOVE!
OR 3-21-98

Whiskey
Dick
12-20-02
Portland

THIS CAR
EXCESS

BLINKIN FREDY TOUR 03'
HOPPO 80S'
EUGENE OR
DEFEND THE EARTH

6/02
"HOBO GATHERING TOUR"
eugene, OR.

C-100-17

WATER BED LOUS IN LOVE!

PDX

Eug OR 12-20-98

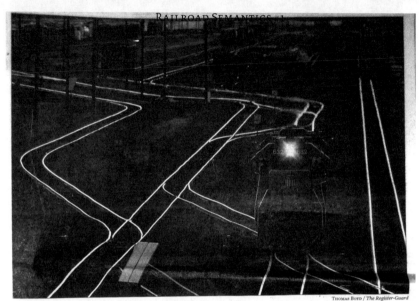

THOMAS BOYD / The Register-Guard

...ain tracks reflect the setting sun at the Union Pacific rail yard in West Eugene, where solvents have migrated into the groundwater.

SWITCHING STORIES

Residents whose wells are polluted by rail yard vapors fume over changing reports

By DIANE DIETZ
The Register-Guard

For a decade, the state Department of Environmental Quality sounded like a broken record on the polluted groundwater that runs under the River Road and Trainsong neighborhoods.

The levels of cancer-causing solvents seeping from the Union Pacific rail yard into the groundwater are so low that it's safe to use well water drawn from the ground for all but drinking, the agency repeatedly said.

"Any use of well water for rec-

reation or gardening does not pose a threat," Greg Aitken, a DEQ official, said in the typical message of reassurance in November 2002.

So neighbors in the Trainsong and River Road neighborhoods went on using their private wells to wash their dogs, water their vegetables and fill their pools. For drinking water, they were supplied by Eugene Water & Electric Board lines.

But in recent years — unknown to residents — DEQ officials and Union Pacific consult-

Please turn to WELLS, Page A14

Tainted groundwater's broad reach

More than 250 homes sit atop groundwater that's been contaminated by toxic chemicals from the Eugene rail yard. Industrial solvents have seeped into many private wells. Also, the state says toxic fumes have seeped into crawl spaces in many homes.

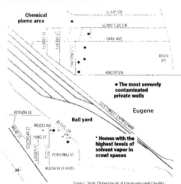

Chemical plume area

FLARY DR
SUNNYSIDE DR
PARK AVE
RIVER RD
KNOOP LN

● The most severely contaminated private wells

Eugene

EDISON ST
Rail yard
WOOD AVE
HAIG ST
PERSHING ST
ROOSEVELT BLVD
99

* Homes with the highest levels of solvent vapor in crawl spaces

Source: State Department of Environmental Quality

STEPHANIE BARROW / The Register-Guard

For neighbors, information is sidetracked

Dianna Jones was uncomfortably familiar with many of the drawbacks of the Trainsong neighborhood rental house she lived in for 13 years.

The house — where she raised her two granddaughters on her earnings as an employment train er — is across Bethel Drive from the Union Pacific rail yard.

Inside, the mold on the walls was so thick that Jones said she drew the blankets over her head at night to try to filter out the spores. At times, sewer-smelling waters buckled up from the ground behind the house. Dust from the rail yard coated her furniture.

But Jones, 58, put up with it

Where else in Eugene could she rent a two-bedroom house for $425 a month?

Yet she was unaware of one problem: toxic solvent vapors in the crawl space under the house, possibly wafting up into the rooms.

Please turn to POLLUTE, Page A14

42

Train wreck halts service

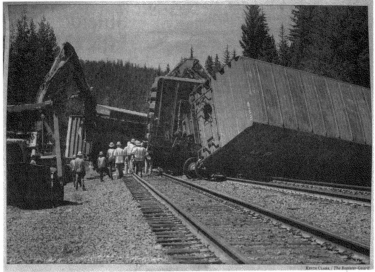

Tracks are expected to reopen today after a derailment early Monday near Odell Lake. Campers nearby were told to extinguish their rigs' pilot lights.

No one is injured when 14 cars derail; one lands on top of a propane tank

BY SUSAN PALMER
The Register-Guard

ODELL LAKE — A Union Pacific freight train derailed early Monday morning with 14 mostly empty cars jumping the tracks a stone's throw away from the popular Shelter Cove Resort on Odell Lake.

No one was injured, but campers were roused and asked to turn off the pilot lights in their recreational vehicles because of a damaged propane tank.

The incident began at 12:38 a.m. at a spot along the tracks known as Cascade Summit, according to Union Pacific spokesman Mark Davis, who said the cause of the accident was being investigated. The 76-car, six-locomotive train was on a run between Portland and Roseville, Calif.

One tanker car contained liquefied petroleum gas; the other covered hoppers and boxcars were empty. Only one set of the tanker car's wheels left the track, and it remained upright with no danger of spilling, Davis said.

However, one of the empty boxcars landed on top of a propane tank sitting next to the tracks. The propane is used to fuel

Please turn to DERAIL, Page A4

Derail: Travelers bused between Klamath Falls, Eugene

Continued from Page A1

heaters that keep nearby switching equipment functioning during the winter.

The propane tank had only minor damage to a valve, and a small amount of propane leaked, according to workers on the scene. A tanker truck was brought in, and the remaining propane transferred to it before workers began lifting the boxcar off the tank.

A crew of about 20 workers from the Rick Franklin Corp. in Lebanon responded with men, excavators and bulldozers to pull and drag the derailed cars off the tracks.

About 120 feet of track will need to be replaced with another 250 feet requiring repair, Davis said.

He expected the track to be accessible to train traffic by this morning.

The wreck shut down the tracks between Klamath Falls and Eugene, and an Amtrak spokeswoman said train travelers were being bused between the cities.

The accident didn't disrupt camping activities at Shelter Cove, resort owner Jim Kielblock said.

"We woke guests up and asked them to turn off the pilot lights" in their campers and RVs, Kielblock said, in response to concerns about the damage to the nearby propane tank. He estimated that about 400 people were staying at the 75 RV sites and 13 lakefront cabins.

Bruce Fonnesbeck, a Springfield resident camping at the resort, said he didn't know about the wreck until he got the early morning request to shut off his rig's pilot light.

First thing Monday morning, he and his grandson hiked the trail near Trapper Creek and got a good look at the rail cars scattered every which way off the tracks, amid the breathtaking beauty of the Deschutes National Forest with Diamond Peak rising in the distance.

"It was something," he said.

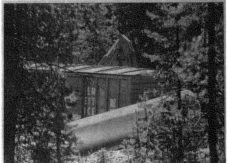

One of 45 derailed cars landed on a propane tank Monday near Shelter Cove Resort.

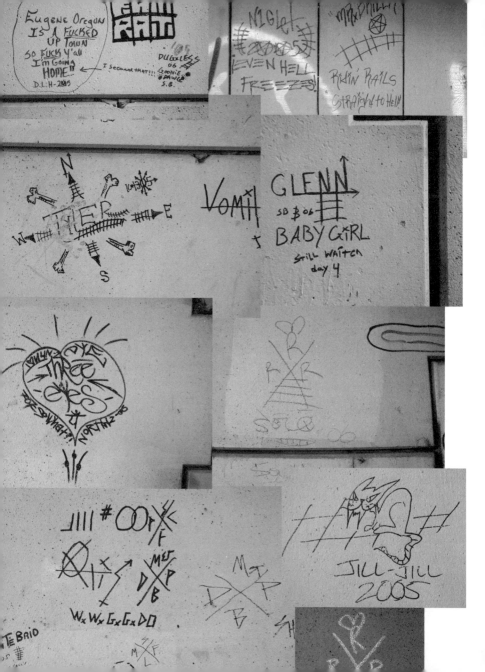

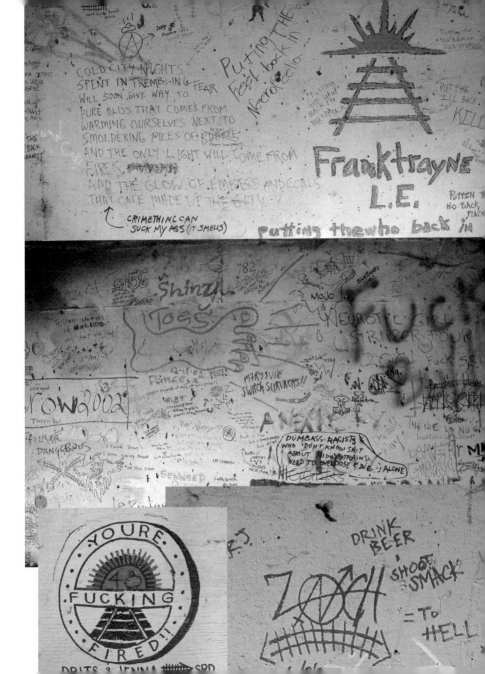

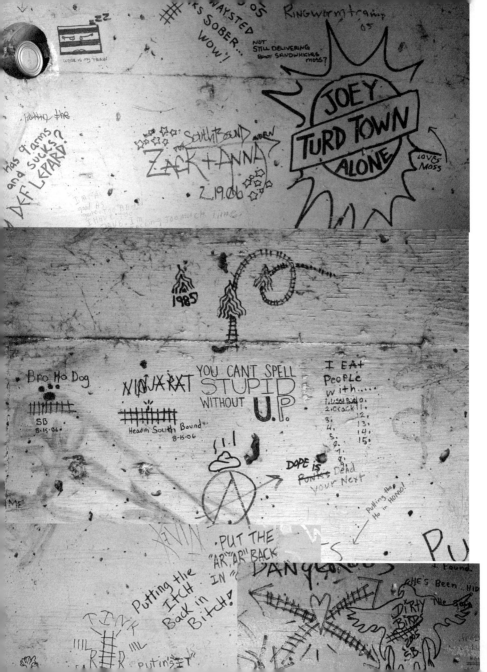

ZIG-ZAG

85

ROVER BFC SBD 6/05
WEN A.D.D.

What up Nate
I saw DYLAN in July!

chicken
D SCHOOL

HEY NATE
HS TEAM!!

MARCH 05
SBD

¿Where's my
DYLAN at?

BFC
NATE

FUNKY 6/05 Haded back
+D+D to MPLS

Lost and
Lonesome

NP
DAYS

Heading South

8-15-06

LIFE
LOSS
CHAOS

Stupid Fly
crew

SBD

TRENT
ridin CORP

D.T. CREW
Days Waiting
|||| NONO
FREAKIN' BORED!!!

DYLAN
06

Sorry
Nate
I'll see
you Again
-Dylan 06

LAME

SCB

STEVE
DAVE

06

UM

62

Nate +3

Ellie may
DEAD

7/05

UH-OH

Stupid

MEAN, SOCIOPATHIC,
INEPT & TOTALLY
FUCKED UP!!...
EWW... GROSS!
PUKE!

665½ = "POWDERKEG"
DT CREW

To my dearest snakes Amelia
It didn't even move with the stealth of a snake that slithered and stopped & then slithered

Look Boss
DA TRAIN
DA TRAIN

First Aid

3 DAYS

NO TRAIN

YUPPIES

DRITS-N-JENNA
YOU'RE
53
FUCKING
FIRED!!
SBD
SBD
7/06

303
G.W.A.R.Y.IN
G.L.H

DAYS '05

SialFl

RAGAMUFFIN

TRAVELIN
4.05.06

SBD CORP
WAIT AT CHAMER
LEFT Over Pass (55
FAR Right Track
R.I.P.

AARON
AWESOME TRAVELIN
4.05.06

Trackside, Eugene, OR

Man fails in try to take train on a joy ride

The transient is found working the levers in the cab of a locomotive in Glenwood

By Rebecca Nolan
The Register-Guard

GLENWOOD — A drunken transient tried to take a freight train for a joy ride early Wednesday, and very nearly succeeded, the Lane County Sheriff's Office reported.

The man managed to move the correct levers inside the locomotive's cab, but in the wrong sequence, the train's engineer told investigating deputies.

The engineer discovered 22-year-old Caleb Joshua Gary inside the locomotive about 1:10 a.m. and ordered him out. He was about halfway toward starting the train but had failed to start the generator, a sheriff's report said.

"He got mad when they told him he couldn't drive the train," sheriff's Sgt. Clint Riley said.

Caleb Joshua Gary

The train, operated by Central Oregon and Pacific Railroad, was idling on tracks along Judkins Road, off Glenwood Boulevard. Judkins Point is a common stopping place for freight trains traveling along the Union Pacific tracks.

The engineer told deputies that he sometimes allows transients inside the cab to warm up on cold nights, but he didn't appreciate finding Gary fiddling with the levers and switches when he returned from a break, Riley said.

Witnesses told deputies that, when confronted, Gary muttered something about wanting to drive the train and began harassing the crew and refused to leave.

He eventually walked away, and deputies found him nearby, walking on Franklin Boulevard underneath Interstate 5.

He was taken to the Lane County Jail on charges of unauthorized use of a vehicle and criminal trespassing.

Officials at Central Oregon and Pacific Railroad did not return calls seeking comment Wednesday. But sheriff's officials were relieved that Gary's dream of driving a train was thwarted.

"The sergeant in charge said imagine the fiasco if he had managed to get it started," Riley said. "Imagine trying to stop that train."

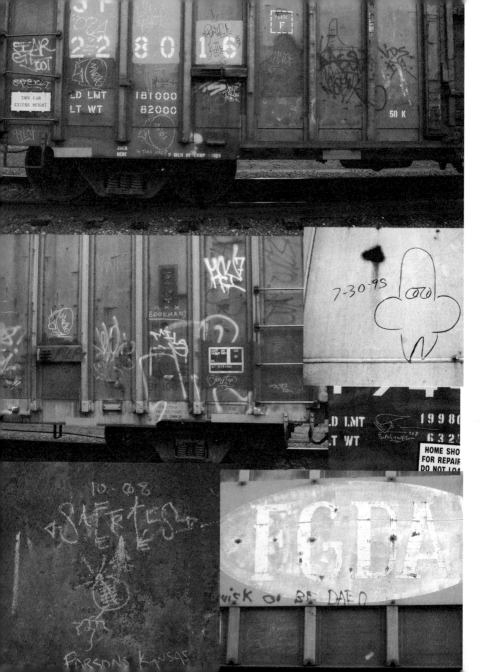

EUGENE TO PORTLAND
(Brooklyn subdivision)

Willamette Valley

I caught north out of Eugene around one or two. I was downtown preying on the library when T-Box called to tell me a northbound had just pulled into the departure tracks. I grabbed my pack from the friend's house I was staying at and headed for the yard. As soon as I reached the tracks an inbound train came blaring through the crossing at Van Buren and I climbed into an empty CN boxcar and rode it all the way down to where the departure tracks begin. The train stopped in the receiving yard, and cut its air. All was calm as I called in the boxcar to find

out it was due to interchange in Portland at BNSF's Lake Yard later that day. Convenient enough, so I sat on it.

The units from the train detached to drop off a short string of cars and then pick up a string of SP chalkboards three times as long. An hour or so later the entire line aired up, pulled down to the departure tracks, and paused briefly under Maxwell Bridge. I walked the line back to look for another boxcar, and as the train inched away, took up the front porch on a bright, orange Potash hopper. Upon departing Eugene began a

There are sheep in the pasture!

light rain.

The ride north was slow, sleepy, and cold, and for the first time in a long while I did not have any alcohol to enjoy, only a little water. The first ten miles out of Eugene took me back across the muddy farms, swollen rivers, and podunk towns I so much enjoy seeing and photographing. Then, between Harrisburg and Albany, the valley flattened out to wide green plots and monotonous pastures, and I crawled

in my sleeping bag to stay warm. I laid on my back drifting in and out of light sleep, looking up at the dim blue sky as the train steadily chugged along. The train must've had some priority because, after clearing Salem, it passed an Amtrak sided for us, but then stopped on the mainline alongside the cemetery in Woodburn for a flashing caution light ahead. There I walked the tracks to relieve myself and gather my bearings, and from then on it was a steady ride through Oregon City, the Portland suburbs, and Brooklyn yard, right up to Steel Bridge, where I caught off the slow-moving train creeping across Steel Bridge, and transferred to MAX.

Arriving in Portland

Broadway Bridge, Portland, OR

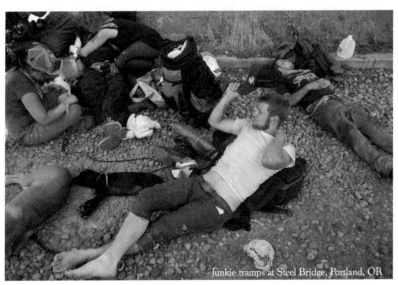

Junkie tramps at Steel Bridge, Portland, OR

Albina yard, Portland, OR

Dirty Birds, southbound, Portland, OR

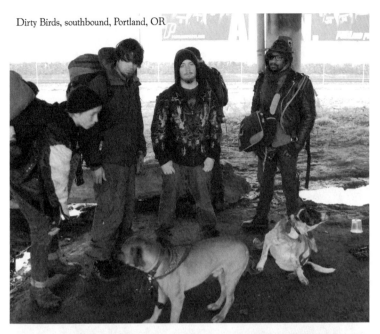

Steel Bridge, Portland, OR

Working | How Oregonians earn their living today

PHOTOS BY DANA E. OLSEN, THE OREGONIAN

Matt Adams, a conductor and engineer for the Portland & Western, stands outside a locomotive idling last week in Northwest Portland's Linnton neighborhood. Adams, 24, has worked for railroads for three years.

In love with the rails, on and off the job

By BRENT HUNSBERGER
THE OREGONIAN

Three years out of high school, Matt Adams found his career riding high above a bed of gravel and a pair of rails.

Adams, 24, is a conductor and engineer with Portland & Western Railroad, shuttling freight trains from Albany to Portland. He recently got a permanent post after logging more than a year as an extra.

"I eat, sleep and breathe it sometimes," Adams says of the job.

He takes the railroad with him even on vacations. On a recent weeklong break, he spent 12 days in Montana with a friend, photographing trains.

Adams says he was drawn to the railroad as a kid, watching freight and commuter trains with his dad, a train buff.

He figures his job is a decent way to make good money without a college degree. But it has downsides: Getting assigned to nights — sleeping in sunlight doesn't suit him — and the long days. His shifts last 12 hours, and he sometimes works six days in a row for the overtime.

People and their cars can get in the way, too, and a train can't stop on a dime. Last Wednesday, he and engineer Skip Stein at one point spotted the tiny silhouettes of two people standing on the tracks at the end of a tunnel, prompting Stein to pull back on the train's throttle and sound the whistle.

Adams and Stein that morning had climbed aboard a locomotive in Portland's Linnton neighborhood that was coupled to a 30-car train loaded with 3,300 tons of logs. Adams kept an eye out the engine's left door as it chugged 10 miles per hour up a 3 percent grade, rumbled across wood trestles spanning verdant canyons and snaked through the 4,000-foot-long Cornelius Pass tunnel to

Adams talks with engineer Skip Stein inside a Portland & Western engine before they pull a 30-car train out of Linnton through the Cornelius Pass railroad tunnel.

Banks, then to Beaverton.

As conductor, Adams made sure the train didn't have cargo, especially hazardous chemicals, it wasn't supposed to. Occasionally, this means spending time on a cell phone ironing out paperwork mistakes from the office, as it did before his train left the Linnton area.

"This list is completely wrong," he tells Stein after walking the length of a 2,000-foot train. "Some of these cars are here, some of them aren't."

By Thursday, his day off, it didn't matter. Adams headed for the gorge. Not to windsurf, hike or fish. To photograph trains.

•

Brent Hunsberger: 503-221-8359; brenthunsberger@
news.oregonian.com; blog.oregonlive.com/atwork

Matt Adams

Age: 24

Job: Conductor and engineer

Employer: Portland & Western Railroad

Experience: Worked for 1½ years at Maryland Midland Railway, based in Union Bridge, Md., before moving to Portland in 2005. Also has worked as a driver for FedEx Ground and as shipping & receiving manager at a crafts store.

Education: National Academy of Railroad Sciences, Overland Park, Kan.

Pay: $17.26 an hour as a conductor and $19.29 an hour as engineer. Made about $55,000 last year, counting overtime.

Hobbies: Photographing trains

Best part of job: Just about everything. "I like sitting up in the seat. I like working on the ground."

Worst part of job: Working nights

Advice to newcomers: "It's going to start out rough, and when I say rough, I mean rough. You're going to be up all hours of the night, trying to sleep during the day, and you're going to get calls all throughout the day. Be patient. Your time will come. When it does, you'll be happy you stuck around."

National Report

At Least 4 Killed as Commuter and Freight Trains Collide

California Crash Injures Dozens

By JENNIFER STEINHAUER

LOS ANGELES — A freight train collided with a rush-hour commuter train in suburban Los Angeles on Friday evening, killing four people and injuring dozens of others, many of them critically. The crash was potentially one of the worst in recent history in Southern California.

Firefighters, using large cranes and ladders, swarmed a toppled passenger car, smashing windows and frantically trying to extract injured passengers as a fire burned under the car of the Metrolink train. A spokeswoman for Metrolink said that roughly 350 people may have been on the late-day train.

The cause of the crash was not immediately apparent. Denise Tyrrell, a Metrolink spokeswom-

Site of fatal train crash

The passenger train originated in downtown Los Angeles.

an, told The Associated Press, "We don't know if we hit another train or another train hit us."

The accident happened just after 4:30 p.m. in the Chatsworth area of the San Fernando Valley, north of downtown Los Angeles. Swaths of red, yellow and green tarps were spread out several yards from the trains, some covered with injured passengers. The engine of the Union Pacific freight train, lying along a 90-degree curve of the track, appeared smashed beyond recognition.

D'Lisa Davies, a spokeswoman for the Los Angeles Fire Department, in an interview with the local NB affiliate, said the fuel from the trains presented a possible hazard.

The Metrolink train originated in Union Station in downtown Los Angeles, and was headed to Moorpark, a suburban area served by many train lines. The crash occurred near an elementary school, and witnesses ran from the area to assist firefighters.

Stacy Sullivan, who was up the

Firefighters swarm a toppled passenger car in an effort to extract trapped victims.

hill from the area of the crash, told television reporters she heard a tremendous boom, then saw billows of black smoke. Ms. Sullivan said she made her way down the hill to help passengers.

Ambulances lined a nearby park as workers tried to find passengers; the dead were removed

from the scene and the injured were whisked to area hospitals.

The crash was near the 118 Freeway. Metrolink trains have begun to carry more passengers than usual in recent months as gas prices have climbed.

The most deadly crash in the history of the Metrolink, the regional rail services for Southern California, was in 2005 near Glendale, where 11 people were killed and nearly 200 were injured when two trains collided with a Union Pacific freight train. The crash occurred when one train hit a Jeep Cherokee abandoned on the tracks by Juan M. Alvarez,

who said he had planned to commit suicide but changed his mind and tried to move the Jeep before the train struck it. Prosecutors charged him with 11 counts of murder, and Mr. Alvarez was convicted last June.

Television cameras captured a male passenger being removed an hour after the crash from a hole in the side of the train and set into orange stretchers. He was set to rest near an engine while firefighters moved back to the ladders to pick slowly through the wreckage in hopes of finding more victims alive.

Greg Miller, a motorist, told

KNX-AM radio that he was driving near the scene when he heard a loud boom. "I thought somebody blew something up," Mr. Miller said. "It was really loud." He said he did not immediately grasp that it was trains colliding, but soon a plume of black smoke signaled the disaster.

People lined a street in Chatsworth, frantically calling on their cellphones, trying to get word on family members who were on the train.

The toppled car was a mangled mass of steel and smoke, with seven freight cars derailed and others standing on either side.

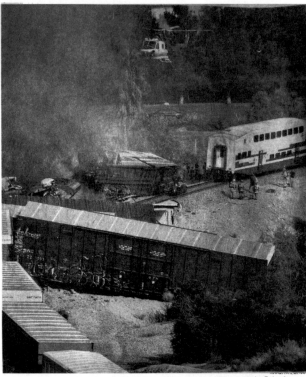

A fire burned under a Metrolink train after it collided with a Union Pacific freight train north of Los Angeles late Friday afternoon.

The Hobo Film Festival, a traveling exhibition, stopped at the 123 Community Space in Bedford-Stuyvesant on Wednesday.

Train-Hopping Traveler's Life, Captured on Film

By COLIN MOYNIHAN

For nearly as long as rail lines have crisscrossed the country, there have been stories about wanderers covertly climbing aboard train cars and riding away from problems or speeding toward some glimmering promise on the horizon.

The paths of train hoppers, tramps, hobos and travelers, looking for work, adventure or merely free transportation, have been recorded in lyrics and in literature. Jack Kerouac, Jack London and John Steinbeck have written about them. They have populated the songs of Merle Haggard and Woody Guthrie.

More recently, filmmakers have documented the experience of riding the rails across the country's varied terrain. And some of those works were recently screened in a storefront community center in Bedford-Stuyvesant, Brooklyn, as part of a traveling cinematic exhibition called the Hobo Film Festival, which is progressing from state to state by way of a $200 Toyota station wagon driven by a 31-year-old train hopper from Asheville, N.C., named Shawn Lukitsch.

On Wednesday night Mr Lukitsch stood on Tompkins Avenue outside the center, the 123 Community Space, where the films were to be shown. Tattoos of train tracks circled his right wrist, and he puffed on a small pipe as he described the appeal of viewing the landscape from inside an empty boxcar.

It is pure, unadulterated, unhomogenized America," he said. "You see everything from

the seediest underbelly of industrial areas to rural places to people's backyards with laundry hanging on a line."

Mr. Lukitsch said that he began riding trains 14 years ago, while living in Milwaukee, and that he had logged about 120,000 miles through the 18 contiguous states as well as parts of Canada and Mexico. He has ridden on rail lines belonging to companies like Union Pacific, Southern Pacific, Norfolk Southern and the Burlington Northern.

He has traveled in the relative comfort of boxcars and grain cars and has tolerated travel in coal cars, which are considered unde-

Documenting the experience of riding the American rails.

sirable because they are dirty and have high sides that afford a poor view. While riding, he has tended off an occasional threat from fellow travelers, he said, and once abruptly exited a grain car standing in a train yard after he encountered a large possum holed up inside.

On two occasions — in Greensboro, N.C., and Wichita, Kan. — Mr. Lukitsch said he was jailed briefly for trespassing. Still, he said, some people who work in train yards or aboard trains are friendly to the travelers even though the practice of hopping trains is clearly unlawful.

Eventually he began using a

video camera to document his trips, and he edited the segments into narratives. Last summer, he said, he showed his and others' movies at the National Hobo Convention, a rambunctious rendezvous that has been held annually in Britt, Iowa, since 1900.

And last month Mr. Lukitsch set out on a two-month trip in the station wagon with about 30 documentary films on hobo life — shorts, trailers and features — that he is showing in 23 towns and cities.

The origins of unsanctioned train travel are unclear but many agree that the early days of the 20th century were a golden era for the men and women who used empty freight cars as a way to get from one place to the next.

Among those thought to have ridden the trains during that time are Jack Dempsey, Eugene O'Neill and William O. Douglas, who later served 36 years as a justice of the United States Supreme Court.

Storied travelers in more recent times have included figures with names like the Flying Dutchman, Mojave Don and Cold Beer Butch.

Strictly speaking, Mr. Lukitsch said, the term hobo refers to someone riding a train while searching for work, while people motivated mainly by wanderlust or adventure are generally described as tramps. Those who refer to themselves as travelers are often younger riders driven by a desire to escape what they view as the commercial aspects of mainstream culture.

Mr. Lukitsch said that part of his motivation in making films

was a desire to document a form of transport that was becoming more limited and difficult in a security-conscious era.

"Freight train riding is dying," he said.

Inside the storefront o Wednesday the lights wer dimmed and the audience passe popcorn as they watched a serie of short films and trailers. The soundtrack was the rhythm rumble of steel wheels on iron rails. Among the cast of charac ters depicted in the films wer people who were often searching — for a missing friend, for the true identity of a legendary rai way graffiti writer known a Bozo Texino, or perhaps merely for the mixture of solitude an exhilaration that can be experi enced as a train speeds through open air.

One of the presentations was a 22-minute film by Mr. Lukitsch called "Spruce Pine to Bostic," which documents a trip he recently took with two friends in a train car full of rebar through mountain passes, swamps and tunnels near the western edge of North Carolina.

Some in the audience had ridden the trains themselves, and during an intermission a young man who goes by the name Thaddeus said he had boarded boxcars not only for fun but also to get to political demonstrations, a tradition he traced to the days of the Industrial Workers of the World, a radical labor union known as the Wobblies.

"It's freedom," he said of the experience. "It's one of the most American things you can do."

NO: ~~bob~~ TO: CDTX ~~2001~~ TROJAN WARS

FOREIGNER
MARTINEZ
(911)

20256(2) 20947(1) 20253(2)

LINE NO.	LIMITS FROM MP	TO MP	TIME FROM UNTIL	TRACK(S) AFFECTED	FLAG AT MP	FOR DIR	GANG NO. / FOREMAN And FOREMAN

***** FORM B NO. 20256 *****
ON 03/31/09 BE GOVERNED BY RULE 15.2 WITHIN THE FOLLOWING LIMITS:

LINE NO.	FROM MP	TO MP	FROM	UNTIL	AFFECTED	AT MP	DIR	GANG NO.	
2.	60.5	59.25	0930	1530	ALL			8857	COLOMBO GETS HIGH
1.	46.25	45	0800	1530	ALL			8034	HAUGH LOW CAN YOU GO

LINE NO.	LIMITS FROM MP	TO MP	TIME MPH	TRACK(S) AFFECTED	FLAG AT MP	FOR DIR	FROM DATE TIME	UNTIL DATE TIME

LIMITS WILL BE BROKEN FAG FLAG I AM NOT Your FRIEND

1.	38.8	40	MAIN 2				03/31/09 0600	

FORM A NO. 20947

LINE NO.	LIMITS FROM MP	TO MP	TIME FROM UNTIL	TRACK(S) AFFECTED	FLAG AT MP	FOR DIR	GANGS ARE FOR FAGS NO. / FOREMAN NO FOREPLAY

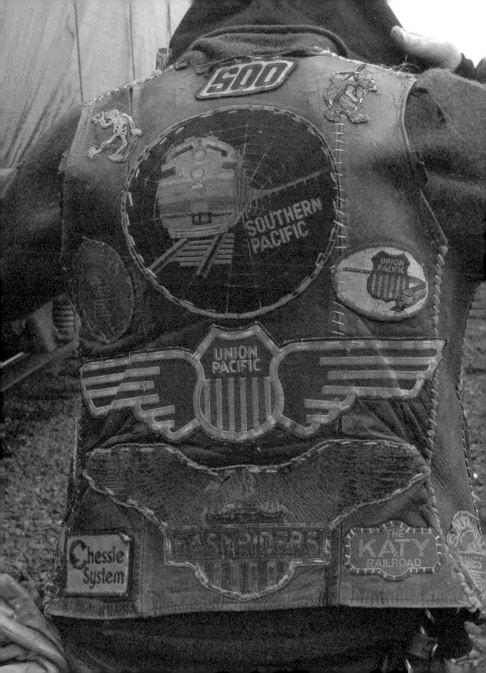

Joe, whats you know? Dec, 9, 08 I saw your
12/08's go by yesterday morning at
Roseville, ☺ No need to let any-
body know, Theres nothing I can do
here. I'm running around doing
cans and plastic bottles and catching
up on a few lost meals, The Brakie
Blew up on me about a month ago
at the camp and dialed 911 on me
over the drawings I was doing on the
flat cars, I got quite a few though
I knew it would blow up some
time. Always does, I thought his
eyeballs were gonna pop right out
of his head, calling me every name
in the book!! Any way here I am
3 pds of cans & 6 pds of plastic Bottles
makes 10 - Bucks! I've only
Been here for 2 weeks I'm on my
3rd week starting monday that
shithole was shot out any how

Yeah, I have my Bike with me too. I get Free-Stamped XMAS CARDS once a week too. I even get a Flea-Bath & 3 Buckaroos too. There's UNLIMITED Resources here too. The Apt. Dumpsters Are Fat as hogs, All the time, The people are a hell of a lot cooler too. There wouldn't I couldn't say the quiet peace ANY BETER ANY place else right now. So I think I'll Be hanging onto this For as long as possible or as they SAY, till the wheels Fall off!! At Least I got money in my pocket AND All I can eat everyday. AND a place to Camp AND sleep. I'm Just now getting my new System organized. It's spread out around here Real good. Saw YOUR SIGN IN the DUNSMUIR CANYON too. It's wet cold AND Foggy Right now. Supposed to warm up next week. TAKE CARE

Joe
ONWARD!
COALTRAIN

and gentle love.
of the first Christmas
Be yours today
and always.

US!

BE OUR "BEST FRIEND FOREVER"

Do you love what Microcosm publishes?
Do you want us to publish more great stuff?
Would you like to receive each new title as it's published?
If you answer is "yes!", then you should sub-
scribe to our BFF program. BFF subscribers
help pay for printing new books, zines, and more.
They also ensure that we can continue to print
great material each month! Every time we publish
something new we'll send it to your door!

Subscriptions are based on a sliding scale of
$10-30 per month. Please give what you can
afford so that we can be sure to send out more
stuff each month. Include your t-shirt size and
month/date of birthday for a possible surprise!

microcosmpublishing.com/

Minimum subscription period is 6 months. Subscription begins the month after
it is purchased. To receive more than 6 months, add multiple orders to your
quantity.

Microcosm Publishing
636 SE 11th Ave. Portland, OR 97214
www.microcosmpublishing.com